Silvia Henke, Dieter Mersch, Nicolaj van der
Thomas Strässle, Jörg Wiesel

Manifesto of Artistic Research

A Defense Against Its Advocates

mixed with *Bildstücke*—
a Declination of the Collage by Sabine Hertig (2019)

DIAPHANES

THINK ART Series of the Institute for Critical Theory (ith)—
Zurich University of the Arts and the Centre for Arts and
Cultural Theory (ZKK)—University of Zurich.

© DIAPHANES, Zurich 2020

ISBN 978-3-0358-0220-7

Layout: 2edit, Zurich

Printed in Germany
www.diaphanes.com

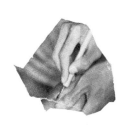

False Competition

Since its beginnings in the 1990s, artistic research has been driven by politics. Without the strict academicization of courses of study in art and design as furthered by the Bologna Reform, the entity we call "artistic research" could hardly have come into existence.

After a number of phases of contouring and consolidation, artistic research has largely become established in terms of its educational, institutional, research, and funding politics. And it has done more than just established itself: it has expanded into almost every field of art.

But we can still see the traces of its self-assertion. As a research practice located primarily in art schools, artistic research has from the beginning been in competition with university research practices: with their institutional parameters as well as their classical criteria of judgment ("state of the art," clarification of methodology, the progress of knowledge, output data, etc.).

And this remains the case: artistic research is still considered at best a junior partner of the academic disciplines— followed by some of them with interest, sometimes taken note of with dismay, and often enough derided.

This is due not only to the universities' sense of owning the domain of research; artistic research itself also bears responsibility. To this day, it derives its self-understanding essentially from its engagement with academic research, and this in multiple respects: artistic research imports academic theoretical models and methodological options, adopts its forms of evaluation and distribution, and strives after respectability through traditional academic qualification formats like PhD programs.

1. **Artistic research can only become permanently established by emancipating itself from university research. Instead, it subjects itself methodologically, theoretically, and institutionally to an academic university regime.**

So long as artistic research continues to direct its focus towards the standards of university research and attempt to imitate them, it enters into a rivalry in which it cannot and should not exist. In this way, artistic research squanders its original potential.

The situation is confusing: while universities become more interested in performative forms of knowledge transfer (under labels like "science days," "lecture performances," or "100 Ways of Thinking") and keep an eye on the applicability of their research and on new courses of study, art schools continue to dream of their own research becoming scientific or academic—under the assumption that this is the way to political, academic, and theoretical legitimation.

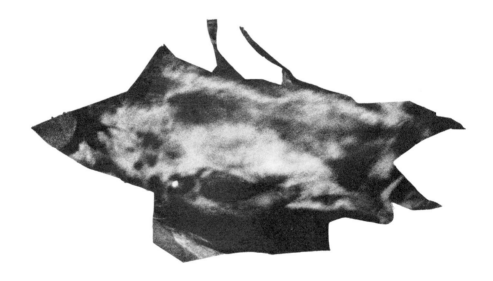

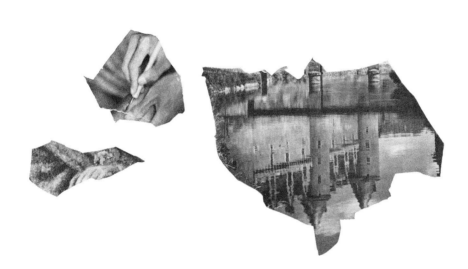

Three Problems

A *first problem* is the personnel. The people who engage in art research, contribute to the formation of theories, and lead research departments at art schools themselves originated in the university system and possess high-level academic qualifications (which has become a decisive criterion in hiring decisions). They often behave like apostates from the academic world and yet reproduce its working methods. They do this according to a strict yet sometimes vague understanding of what can be called "research," in terms both of their language and their goals and research methodology.

A *second problem* are the aesthetic and philosophical reference points. Currently, the defenders of artistic research are working with a relatively coarse-grained understanding of theory, discourse, and reflection which hinders more than advances the development of a specific praxis of artistic research. This is also due to inadequate analogies: invoking, for example, terms from scientific research like "laboratory studies" and "experimental systems," language which misleads from the beginning, as if, on the one hand, the artistic element of research exhausted itself in a series of experiments and, on the other, as if research were an art whose privileged site is the laboratory.

Another research paradigm is advanced by the qualitative and quantitative "surveys" and "observations" as borrowed from the social sciences—with the hope of being able to objectify the vaguenesses of artistic research through the voices of the many. Another field is ethnography: it seems as if the arts are preferentially equipped with a foreign gaze which is able, so to speak, to regard the world with the eyes of the other in order to glimpse its hidden cabinets of curiosities. These are skewed analogies: through them, aesthetic procedures are only made to seem similar to the sciences, with the result that they lose their specific form of intellectuality, and particularity with respect to the sciences.

A *third problem* exists in seeking refuge in fashionable theories. Historical epistemologies, "actor-network theory," "object-oriented ontology," or "new materialism," as well as privileged thinkers like Gilles Deleuze, Michel Foucault, Karen Barad, or Donna Haraway are not so much read and criticized as used and exploited as citation sources. Theoretical building blocks are manufactured which do not even attempt to understand aesthetic thought. Instead, empty ciphers are employed, and are hastily filled in with the procedures of artistic research. The orthodox insistence on "research questions" and "research results" also leads to schematic applications which conceive of theory not as a reflexive work of thought which is to be modelled but rather as an activation prosthesis. Through this, the potential of artistic research to question the sphere of validity of conceptual labor is wasted—as is the possibility of dynamic dialogue between conceptual reflection and the practices of aesthetic reflexivity.

2. Artistic research is not a playground for failed academics. Nor for failed artists.

It is remarkable how trends in artistic research are taken up only reluctantly by artists, or even how artists consciously reject this label. The reverse is true of academics, who readily assume the label to position themselves at the forefront of the movement and to theorize it. From this results a terminological culture of certification, which invokes and calls on the stereotype of theory rather than arguing autochthonously, allowing itself to be guided by the genuine power of the aesthetic.

These conjunctures are correlated with an overt focus on *output* which calibrates artistic practice to verifiable and comprehensible results which can be distributed in publications or on websites. This way of thinking conceives of itself as critical of institutions and power structures, and always contradicts itself when it gathers around the pots of money from the funding institutions behind university thinking.

A methodological conflict is ignited which not only vaguely speaks about methods—reproducing their immanent

conditioning—but also fails to recognize that the arts do not proceed according to a strict method (*met'hodos*) along a predetermined trajectory, but rather in the form of leaps, digressions, and detours which continually generate new and unexpected counter-expressions, and do not set a goal for their nonlinear "experiments," but instead trigger irritations and thus daring revelations. If artistic research were able to draw these practices out from art, to develop them further and to productively incorporate them into academic discourse, we would have to reckon with an academic revolution.

At the same time, artists enjoy collaborating with scientists and academics, particularly in the natural sciences, with an eye to drawing level with them. New words like "artscience" or "scienceart" arose to emphasize the transdisciplinary potential which mainly exists for art to provide new ideas to science, to present them with another form of creativity, or to outline perspectives that had not been considered before. We can in no way speak of a "dialogue" or "encounter" of equals. Instead, the methods of the arts remain just as misunderstood to science as the reverse.

3. **Multiple misunderstandings block our perspective of what artistic research can be—in the sense of research characterized by its own form of thinking as distinguished from that of established artistic and scientific praxis.**

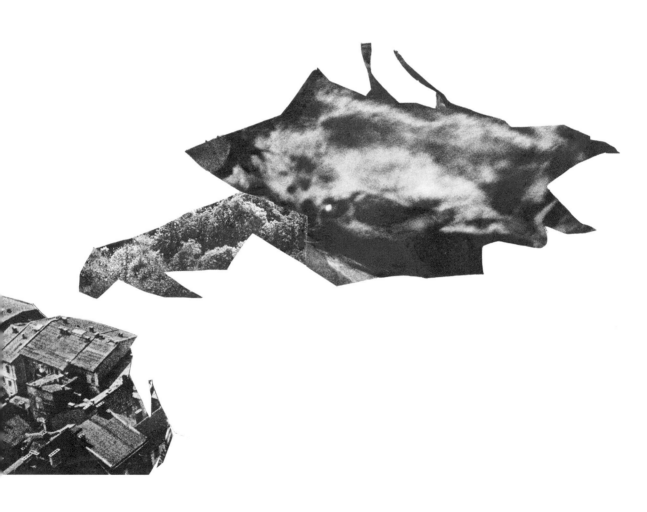

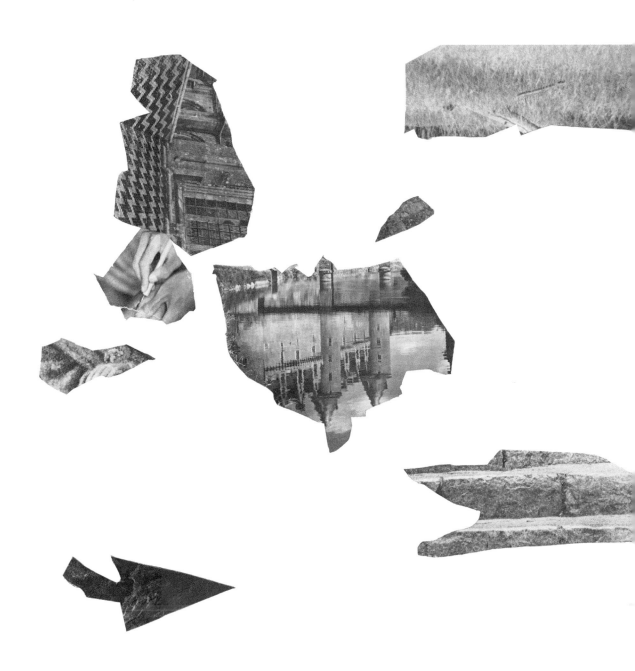

Four Misunderstandings

First, there is a pervasive conviction that artists are primarily active as researchers when they are gathering and processing as much information as possible. This leads to an art qua "research art" which is no longer accessible without displays, roundtables, and accompanying publications, and which presents itself in the form of impenetrable exhibition installations that aim above all at putting one thing on display: the bewildering complexity of relations, mostly borne by a massively interventionary curatorial discourse.

Second, a research practice has established itself which uses—and abuses—art in a secondary capacity, rather than working in and with its own form of thought. This practice refers back to procedures of social research, of "grounded theory," or of research dispositives situated in the realm of information technology. It uses strategies which do nothing more than present spectacular fireworks of the senses that are only intended to amaze. Statistics, interviews, participatory observation, data visualization, technological innovations, or the standards of scientific experiments, spiked with a scattering of more or less random commentary, obstructing our view of actual artistic agitation, the practices of traversing media and materials up to the point of an upheaval which can open up what remains inaccessible to the methods of science and technology.

Third, an understanding of research prevails which imitates the granularity and specialization of academic knowledge generation in order to affix an artistic signature to far-fetched or marginal questions which aim at nothing more than miniature shifts in the fabric of something which has already been shown, said, or analyzed a hundred times, as if research consisted solely of occupying niches or of variations on and applications to as yet unexplored objects. The term "artistic research" is often nothing more than a label which is retrospectively applied to aesthetic productions to increase their legitimacy.

The point, however, is to understand artistic practice and artistic research as kindred practices, to be sure, but not necessarily identical ones. Artistic research stands and falls not on its connection to art but to aesthetics. The attribute of *art* is not essential to artistic research but rather the term *aisthesis*, sensual knowledge. It makes no claim to autonomy. But artistic research justifies itself in those places where it intermittently intervenes in scientific discourses as well as in everyday worlds, with the purpose of further developing these, transforming them or causing shifts in them and, in surprising and sometimes incomprehensible ways, driving them forward.

Finally, it seems, *fourthly*, to be sufficient for understanding oneself as "engaging in research" if one's own praxis, in whatever way, challenges the hegemony of institutionalized academic research and frustrates its claim to sole legitimacy. The emphasis on a genuinely "artistic" research interest is apparently sufficient to understand oneself as subversive, critical of power, and an activist. This disregarding the fact that such a politics of negation indirectly plays into the supremacy of scientific knowledge—by jealously attempting to imitate it and simultaneously refusing to develop its own positive notion of knowledge.

4. **The potential of artistic research consists in asserting undisciplinarity, allowing for uncertainty, integrating negativity, and searching for clarity. This is considered insufficient by a rigorous understanding of science.**

Artistic research is not the research of art. "Researching" is a form of "finding." There is always an element of chance in finding. For this reason, "knots" (Ronald D. Laing), complications, and even confusions can guide processes of finding—and not the strict, straightforward "search" (search, research, *recherche*) by means of a system or models which have been otherwise legitimated.

Researching in the sense of finding without having sought begins when all expectations for theory are exhausted and the formation of concepts and methods seems to be concluded. Then the autochthonous power of exhibiting, showing, or witnessing becomes significant, things which are to a high degree woven into sensuality and operate with multiple perspectives. Research is in no way bound to follow norms like propositionality or discursivity or to serve scientific exoterica.

Instead, artistic research is, as something aesthetic, in possession of the quality of singularity. From the viewpoint of practice, it manages to dwell in various zones of uncertainty, of negativities, unclarities, or frictions, to work with fictions and disruptions and to invoke the subtlest details with accuracy and clarity and to make them aesthetically manifest. The subject of such research is consequently the unspeakable and unrepresentable as well as forms of incommensurability which unfold their own tension and intensity and effect the production of knowledge. This requires the concession of specific faculties. They disclose themselves alongside concrete practices.

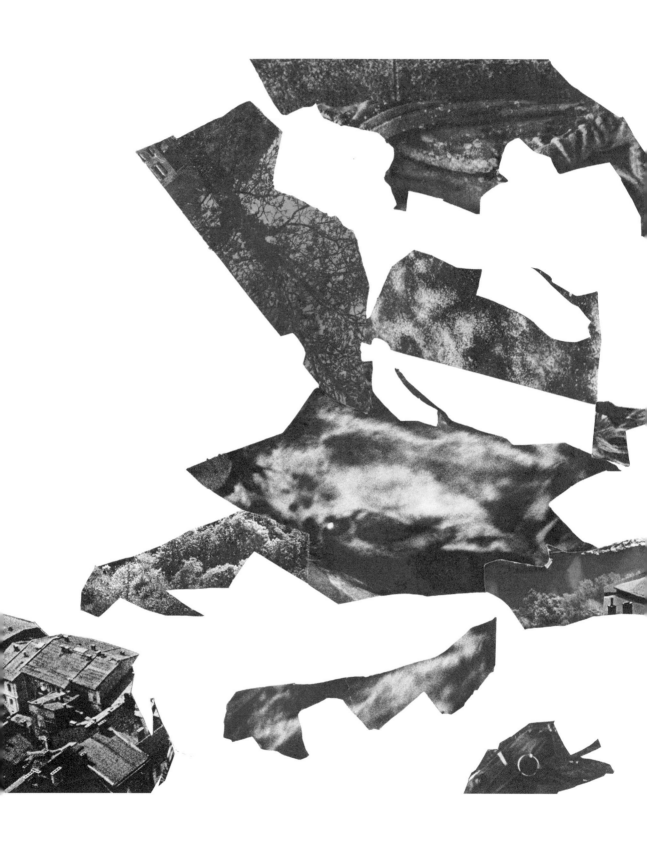

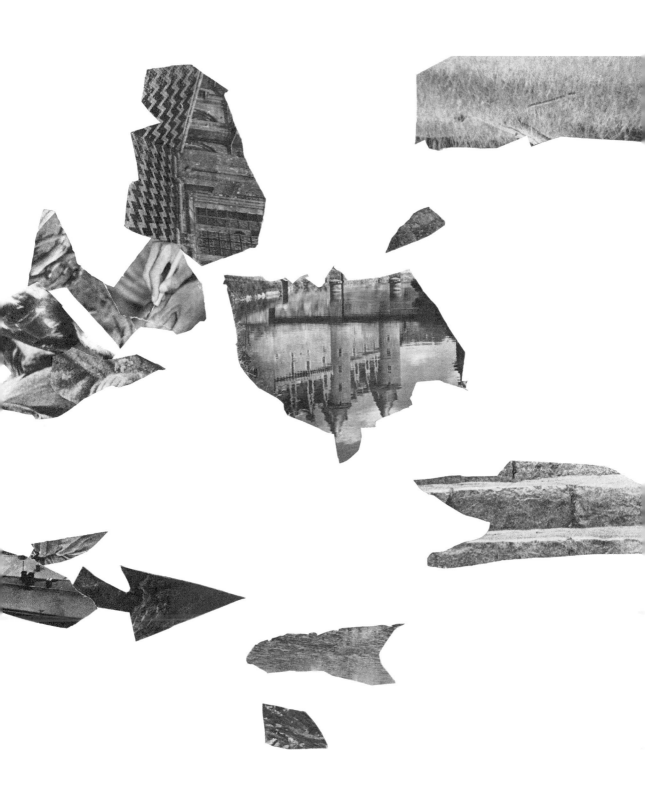

Theory And Practice

The notion of practice, as connected to the arts and trades, increased in standing with the publication of the *Encyclopédie* (1751) by Denis Diderot and Jean-Baptiste d'Alembert. Today, wherever the term appears, it is bound up with a promise. As nearness to concrete action, to work, or to the actually happening, this promise relates to utility and a solution-orientation, to practicality, usability, usefulness. "Praxis" suggests not only an implicit factuality but also at the same time the ability to control the real, an intervention in its relations, a power to act which enables change, whether in politics, education, the social sphere, or the sciences—or in research at art schools.

The relationship of artistic research to its sibling, design research, has kept alive the question of a focus on application. We could say that the focus on applicability (*mode 2*) has given artistic research the *ability to survive*, while the focus on basic (*mode 1*) has made it *respectable*. That artistic research still strives towards academicization also shows that it does not immediately want to admit being part of the professional higher education system.

The political solution was the introduction of a new category: "Use-inspired basic research" like that of the Swiss National Fund. Artistic research could never fully escape the dilemma existing between a focus on application and a focus on fundamentals and foundations. That might be one reason it appears to be more interested in technology than the dimensions of the aesthetic.

Applicability and praxis-relevance are, then, the key factors for the success of research proposals. Preformulated hypotheses, methods, and anticipated objectives serve to normatively sanction the conventions of knowledge-generation, to keep them controllable, and to channel their procedures in a results-oriented direction. The suggestive effect of praxis leads to a belief that praxis could precede or guide theory, at least in some areas or disciplines. In *mode 2* of academic research,

this praxis focus proves to be even more important than fundamental research, which once directed those in *mode 1*.

The concept of "praxis" in particular presents itself today (again) as if it could stand alone and be valid on its own. It is enough to invoke practice as a kind of magic formula through which everything can be solved. It is assumed that the practical is even more powerful than theory, that praxis can get along without theory, that it is even an a-theoretical event which could cheerily act under pragmatic slogans like "against theory" without securing its own foundations and teleologies. The idea (again) prevails that there is a yawning abyss between theory and praxis, an idea where theory is abstract, gray, superfluous, weak, and distant from life, while praxis advances directly in the glow of its promise of results. Everywhere in common rhetoric, praxis scores points as something concrete, as a force which "works," driven by the élan of actionism or acceleration.

What is forgotten here is that there is no single, unitary "praxis," that it remains relegated to an environment from which it can be formulated and understood. Practices, like theories, are always "related" and thus relative to the contexts and situations in which they are embedded and to which they provide answers. In particular, they are linked with the real by virtue of their performativity. As performative, however, they are already in possession of a temporal horizon; they emerge from something as they point to future which they do not know and do not have access to. Practices for this reason evade control, which is why they require reflection, without which they would fall into sheer positing, even into violence or ignorance. Their reflexivity—their grounding in insight, perception, knowledge, and self-referentiality—guarantees their revisability. This reminds praxis that it has consequences leads to side-effects which it sometimes did not intend and is not in a position to take back. No praxis is in control of itself, neither with respect to the future towards which it is moving nor to the past from which it emerges. This is also true of artistic practice, which can only manifest itself as art if it remains mindful of this dialectic in every moment.

5. **Praxis requires theory just as theory requires praxis. Practice-based research has nothing to say to artistic research if it rejects reflection and reflexivity.**

The dichotomization of theory and praxis thus proves to be fatal: it does as little justice to art as to aesthetic research. But theory, too, does not exist "for itself" as a pure abstraction. Just as much based on a history, a social space and its conditions, and communicative contexts, theories themselves shape practices which, as discursive practices, follow their own rules. Linked to other theories, to debates and social discussions, they are always interventions and infringements, initiate polemics and escalations, even launch provocations whose performative energies are no less intense than in practical struggles.

Theory is consequently not the antithesis of praxis, just as praxis is not an antithesis of theory. But neither do they merge into one. They do not even make up a continuum, but instead interact with each other at a distance, in a break which pushes them into an ambiguous relationship. The separation of theory and praxis is thus misguided when it attempts division into disparate spaces or competencies which do not allow of mutual contact. If this separation secretly gives priority to praxis, it gives away not only its potential *as* a praxis which encompasses and contains a *theoria* (literally "perception," "insight," or "observation"), thus operating both analytically and sensually—it also gives up the potential for an epistemological form of acting which knows its own validity and limits.

On the other hand, "wild" practice forgets that it is not just a position within the historical-ideological order of pragmatism, which prefers goals, objectives, and effectivities, but rather that it is precisely this order and its thoughtless production that can trip up praxis and impose on it the necessity of a "curving backwards" or "turning around" (*reflectere*). Something similar is true of theoretical work regarded in isolation, which persistently revolves around itself: it too can get tangled up in itself, lead into error or chase after chimeras by getting lost in theoretical fictions or irrelevant micro-questions.

Whoever continually fails in acting requires an appropriate reflection on acting in order to understand the causes of this failure. And whoever continually uses the same theoretical terminology sees him- or herself, whether in the short term or the long term, as subjected to an incomprehensible world, one which remains unsolvable. Practices are never complete but the opposite: prone to mistakes, sometimes breathless and loaded with errors. At the same time, theories are never innocent or legitimate in themselves but instead relative and thus sometimes prejudiced, narrow-minded, or even possessed by a Tourette's-like compulsion to repetition. Where both are treated separately and remain distinct, they both get carried away with their own self-deceptions or get trapped in the labyrinth of their own interests, remaining blind to contradictory views and collateral damage.

It is thus a truism that practice, in the moment of its performance, is sufficiently and adequately conditioned by circumstances, just as it is a truism that theory is abstract and at best preoccupied with itself. To this extent it must be admitted that the alleged primacy of praxis with respect to theory is nothing more than a tactic: repeatedly proving again that theory is gray, a sentence spoken by the Devil in Goethe's *Faust* to confuse the students. This is all the more reason, from the perspective of artistic research, for a recalibration of the relationship between theory and praxis—a "between" that separates as well as divides both.

6. Artistic research calls for a genuine concept of praxis and knowledge

The discourses surrounding the "knowledge of the arts" and the "cultures of knowledge" lying at the origins of artistic research have not been sufficiently able to reveal the potential of artistic research. The frequently varied thesis of a crossover between science and art is not false but misleading. We certainly have grounds to state that artistic research is also in possession of a genuine form of knowledge, just as scientific

practice occasionally behaves artistically in the experimental system by making use of intuition, creative leaps, and artistic methods like serialization or recombination. But what do we gain from this analogy? The concept of knowledge presupposed by artistic practice hardly goes beyond the classical definitions which determine knowledge "theoretically," bind it to "verifications," and reduce it to a "propositional format," as if only that is "known" which is "comprehended" through definitions and can be classified as "true" or "false." This understanding of knowledge obscures the particular nature of the aesthetic, assigned as early as Kant to another, "third" terrain "between" theoretical and practical reason, a terrain which is neither one or the other.

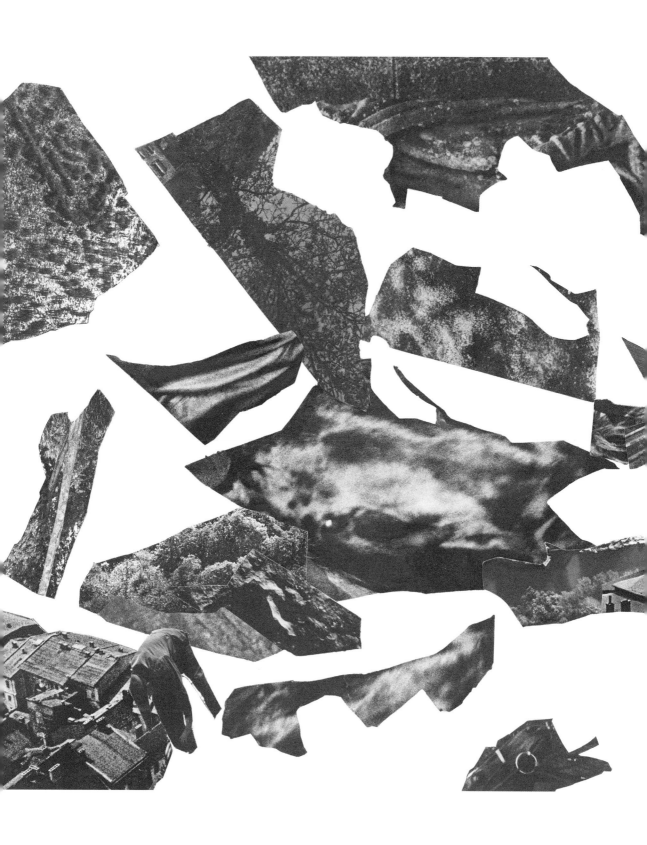

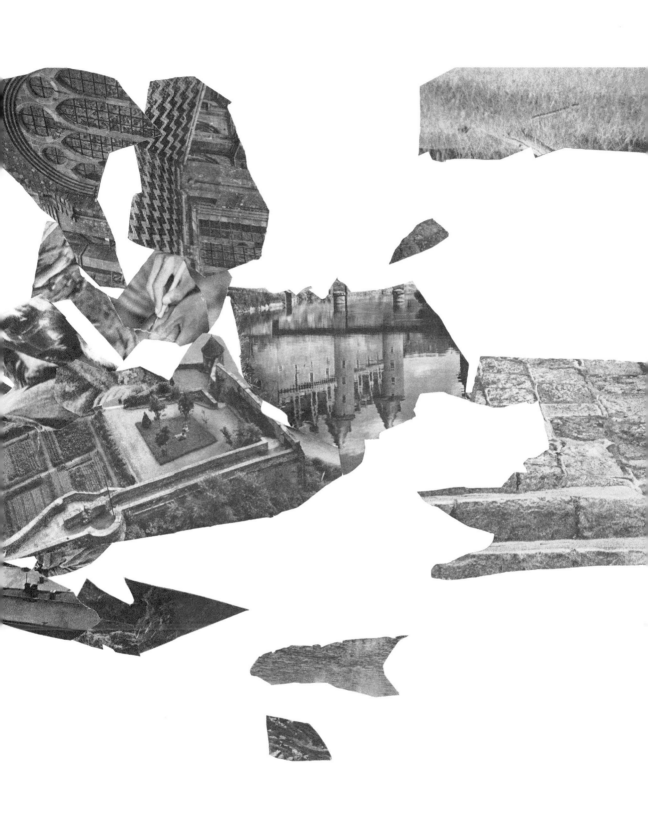

Aesthetic Knowledge

An understanding of knowledge based on scientific knowledge will necessarily reproduce received institutional scientific practices and thus apply principles like evidence, methodological foundations, empiricism, and the experiment to the heterogeneity of aesthetic practices. This can be seen, for example, in the concept of *tacit knowledge*, based on the work of Michael Polanyis and also prominently invoked in artistic research. According to this concept, the practical is in possession of an inexpressible capacity which remains implicit and is embodied secondarily in the respective works.

This also unintentionally formulates the inability of the arts to explicate themselves. Aesthetic praxis, the field of action with which artistic research is concerned, itself induces explication *with* its own—other—means and *in*—other—media. Doing (*praxis*), creating (*poeisis*), and skill (*techne*) thus intertwine in a specific way: the drawing of a line is already an explicit kind of knowledge which presents itself *as this line*; the use of specific materials is not mere convention but instead *a conscious choice* which reveals a resistance or autonomy on the part of the objects; a sequence, mixture, or layering of colors contains the knowledge of its intended effect, or which overall effect emerges from it as a whole; a note which follows another as a counterpoint or riposte is explicitly aware of the contrast it sets—how rhythmic punctuation is aware of the pulse it invokes; and finally a figure which scans and interrupts a text consciously induces an ambiguous image which causes the flow of speech to branch out into unexpected connotations.

It is thus misleading to suppose a "knowledge" on the part of the arts which enters into competition with discursive or scientific knowledge in order to emulate its predicability. But it is just as misleading to speak, as has been done since the origins of philosophical aesthetics in Baumgarten, of "aesthetic" or "sensual" knowledge which is simply confused awareness in need of clarification or "enlightenment." Aesthetic thought is not subordinate to philosophical or scientific thought, or its explication through language; it simply

uses other medial forms and types of expressivity. It calls for a particular kind of validity which does not comply with discursive demands for validity and yet is also not subordinate or inferior to them.

And not least, we are third of all misled by the belief that specific "practical" forms of awareness exist beyond the alternative of discursivity or aesthetics—based on skills which are solely available to those who practice, which they have incorporated into themselves and which can be traced back to some kind of vague intuition. All three versions instead reproduce the hierarchies which have obscured aesthetics as an autonomous realm from the beginning, and whose prejudice today continues to be felt in artistic research and will continue to do so for as long as it is not prepared to reclaim a concept of knowledge of its own, one which neither postulates a specifically practical knowledge nor invokes theoretical knowledge gained elsewhere.

7. **To do justice to research in the arts, we need a determined analysis of its practices and a revision of the traditional categories for the description of art—particularly the subjective centrality of the author, the connection to philosophical truth, as well as the definition of inspiration, creativity, originality, and imagination.**

Research is without a doubt grounded in an act of doing but is in no way indispensable to an ordered or systematic mode of action which aims at verifiable and/or falsifiable results and is oriented towards "the progress of knowledge." Accordingly, research in the aesthetic does not result in a "work" or "product" exposed to measurement. Research also does not refer to a linear setting which moves from hypothesis to hypothesis with the goal of deciphering a causal nexus or asserting accordance with laws. It is instead sufficient to speak of a continuing reflexive process within practices which operates self-referentially and thus relates to processuality itself: the selection of the relevant elements, their location and combination in the construction of the search, their sensuous presence and

explosiveness, their materiality and mediality, as well as every moment and detail of their design work. The aesthetic thus encompasses a totality where nothing remains coincidental or even simply imperceptible, and whose precision can be measured by how consciously all of these parts or aspects are brought into relation with each other.

Traditional concepts in the theory of science like "method," "result," "criterion," or "evidence" are not useful for processes of this kind. Aesthetic practices do not exist as a prescribed repertoire. They can be neither canonized nor classified and are instead engaged in research in the sense of an always singular *pro-cedure* (from Latin *procedere*, "to go forward"), an *avant-garde* with its own rigorousness and radicality. The comparison with scientifically established methods is in fact misleading, and yet aesthetic-artistic research can extrapolate successful examples from the past as well as the future. They resemble examples, not paradigms, and thus play into the hands of an open heuristics and tentative approach towards possible procedures and attitudes.

The 20th and 21st centuries revealed, in philosophy, psychoanalysis, art and literary theory and practice, new ways of posing questions of action, materiality, and mediality as nested and developed in praxis. These are forms of an uncertain *pro-ceeding* which is aware of the precariousness of its "procedure" as well as its accelerating course, and thus that with every step it needs to reassure itself again about the terrain it is on. Just as "knowledge" supposes a "knowledge of knowledge," art is always "art about art," the work of which appears inscrutable and sometimes even circular, without this circularity being a counter-argument. We see instead in this circular movement a gesture of searching which is always catching up with itself in concentric courses, in every moment recalibrating what "art" means.

But this can only succeed if the practices of the aesthetic in Hannah Arendt's sense are not understood as "know-how," which could be distilled to technical operativities, but themselves follow an "art of acting" which places thinking, speaking, and doing into an appropriately proportional relationship with each other. That art, or rather the aesthetic and its praxis, is in turn described in this way with another "art," the

art of the practical, points to the fact that aesthetics, like art, cannot be explained without reference to the aesthetic and to the artistic, that we are confronted with a sphere that fulfills the function of what Hans Blumenberg called "absolute metaphor."

8. The research practices of the aesthetic are a continuing process in which action and reflection unceasingly intersect.

The type of practice which interlaces thinking, speaking, and doing in this way materializes primarily in experiments, trials, and exercises which repeatedly begin anew and in doing so open up other spaces of thought and possibilities for action. This type of praxis can be summarized as a form of *ascesis*, one less concerned with austerity—even if achieved with discipline—than with the careful fabrication or treatment of functions which are "artfully" expressed. This praxis presumes concentration and self-education. Practical knowledge is required, but the aesthetic theory we have in view, as *ascesis*, demands more: its praxis of exercise corresponds to the *exagium* ("weighing and considering") of the essay, a genre characterized by repeated new beginnings as well as "walking in circles," in the sense of a continuous illustration or demonstration, which in some cases has an exemplary function but can never be brought to a final conclusion. The findings of aesthetic research thus do not culminate in propositions but in provisional posits.

It is impossible to mold them into assertions or theorems. The aesthetic can only unfold its immanent potential if it is understood neither as an end which sanctifies its means nor as the retrospective application of a predetermined objective, but only if it is opened to the unpredictable and incalculable. Every "theory-praxis" and "praxis-theory" must therefore first be developed on its own terms. It exists uniquely and singularly. Research in the aesthetic to this extent means a form of spontaneity. It remains particular: situated and terminated, it orients itself to the "case," to the concrete objects it relates

to, to the contexts in which it intervenes. The characteristic of the aesthetic *episteme* is this relatedness of knowledge, its respectivity and singularity. It also seems necessary to reflect on a sense of the theoretical in which not just sight and insight are tied in a firm knot but which also keeps in mind the site of thought's emergence. It is not just the aesthetic and the singular which always belong together but also the event and the materiality of its situatedness; this reveals the authentically aesthetic dimension of thought.

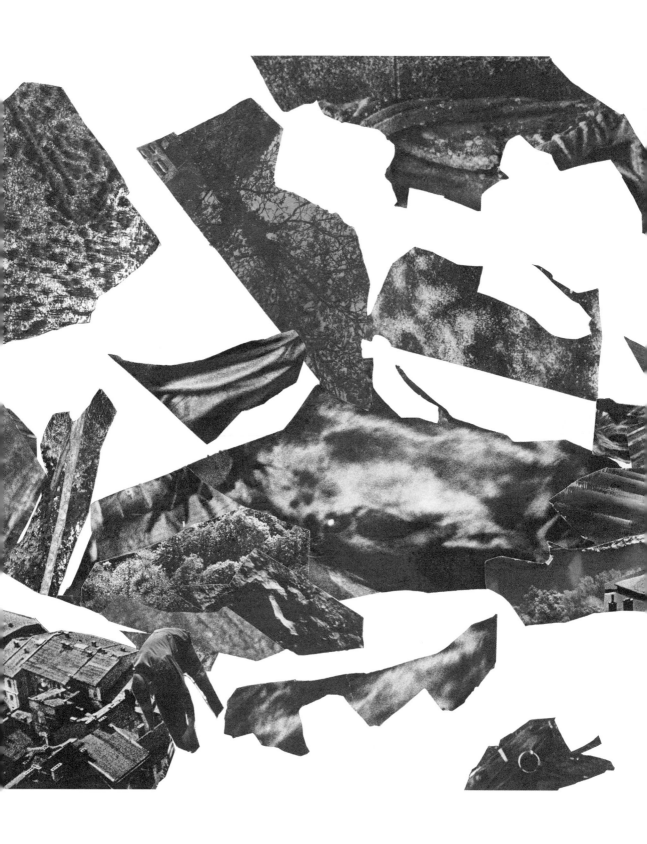

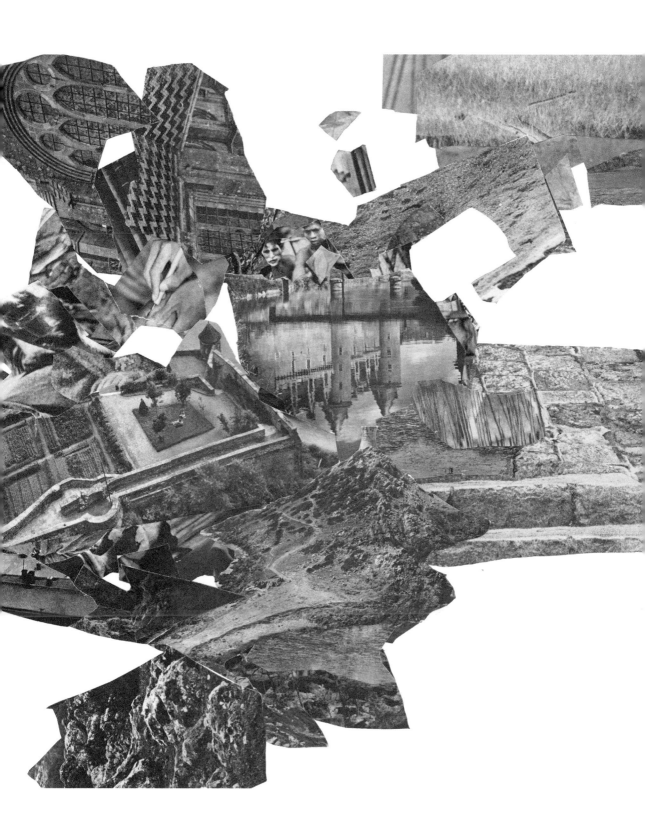

Practices of Aesthetic Thinking

If we want to reconfigure the traditional oppositions between theory and praxis, then we should consider two types of inter-relationship: one is the "praxis-theory" of aesthetic manifestations which opens up new spaces of thought and relation through its particular connections, and thus gives rise to its own, non-discursive knowledge in the shape of a fruitful constellation of materials, objections, actions, outlines, images, or sounds. These form those "languages of things" which Walter Benjamin wrote of, which, as languages of the singular, must be distinguished from discursive modes of speaking. They think multimodally, compositorally, and, in many media, simultaneously. Their specific character consists in making accessible to the perception both their specific treatment of shapes, gestures, and events and their particular means, media, and technologies. Every image thinks in its "color skin" about the relation of surface and surrounding without being inscribed with the "concept" of color skin; every figure refers to its ground, where it seems to be designed without making the ground *as ground* itself thematic; and every performance has in mind the body of its presentation without being in possession of a definition of the body's bodyness. *They present them*. The mode of their aesthetic manifestation is thus the *showing* that always shows itself. It allows something to appear, just as it simultaneously allows appearing to appear. Aesthetic manifestation thus functions, in essence, phenomenologically.

Aesthetic practices map out non-scientific epistemologies by drawing their form of knowledge not from syntheses but rather from the sensuous relations of non-predicative conjunctions in which their insights merge and coincide. In the aesthetic, conjunctions—"and," "or," "as," "both/and," "either/or," etc.—function first of all disjunctively: they reveal divisions before creating connections; or more precisely, what they connect they reveal in their respective disparity. Compositions are combinations, montages, or "splices" without specific rules, not focused on identities but instead co-presenting the incompatibility of the elements, their nonsense. Adorno

thus spoke of the art of a "synthesis without judgment" which is at best "similar to language," although those who take it "literally as language" would be chronically misled. Free of judgment, it is also asynthetic: the color skin never becomes skin; a metaphor never becomes a proposition; a display never becomes a game.

9. The "praxis theory" of aesthetic research is based on practices of difference, not on logics of identity.

The standard by which aesthetic thought should be measured is consequently not the confirmation of a truth or reality but solely the evidence of a moment. Such evidence is to a certain extent unassailable, for we either see (into) something or we remain silent. There is for this reason no sum which could be obtained through the evidence of aesthetic practice: its intrinsic epistemic potential is instead failure, admitted into the experience of a chronically interminable process of finding. Put another way: aesthetic evidence of the result of a praxis which constantly begins anew, reverses, becomes entangled only in order to begin again and, in the process, to invoke its own theory.

Alongside "praxis theory," there is a second type: the "theory practices" of discourse itself, which are not only adapted, expropriated, everted, and counteracted but also exhibited in their aestheticity and thus unmasked in their appearance, in their genuine unfulfillability. In this way, every discourse becomes something other than what it was: not an argument fulfilled in judgment, evidence, or refutation, but one where a transgression was at work, as that which is expressible can only be expressed in an aesthetic manner. The aesthetic in fact preempts all discursivity. If philosophy is the maid of theology, then the question, as Kant polemically put it, is whether the maid advances with a torch or pulls the train behind her. The same is true for the relationship between aesthetics and theory. If we accept that the aesthetic always implies a form of thinking which has from the beginning shaped language in the sense of rhetoric, and which in this way has already for-

matted the classic knowledge formats, then the sciences, especially the techno-sciences, which today dominate the universities and funding institutions, no longer believe that they are exemplary. It is rather the aesthetic that constitutes the first criterion of a kind of thought which must have come forward in all sciences on the basis of language, or the models and their media, the structure of experiments and visualizations.

From this emerges a rich repertoire of intervention possibilities for research (however understood), of new forms of expression, writing scenes, or improvisations together with their "misuse," as we see not only in the essay but in all other artforms of the fragment, the maxim, aphorism, and rhapsody, where aesthetic and discursive thought engage with each other, interlacing with each other performatively. Aesthetic "theory practices" thus serve a kind of thinking which is not in possession of its materials in the sense of an external regiment, but which rather thinks *within* and *from within* this material. In a well-known formulation, Adorno referred to such practices as "methodically unmethodical," to the extent that they neither follow a linearization nor a continuum of operations: they are owed to a *com-position* of moments.

10. Aesthetic research refers to a praxis of thought subject to its own laws. It is "older" than the practice of the sciences.

There can be no doubt about it: artistic research is above all a unique and unmistakable form of thought. It is rooted in practices centered in what we could, analogously to Hegel's dictum concerning the "exertion of the concept" (*Anstrengung des Begriffs*), call an "exertion in the aesthetic." This exertion is a work *on* perception and *in* perception, and formulates the specific program of aesthetic research. If we differentiate here between the artistic and the aesthetic, then it is to award the latter a broader extension, even if both mutually include each other. Artistic research presupposes an aesthetic. This does not describe an epistemological stance which expresses its knowledge by means of an *aisthetic*, taking on the particular

difficulty of making itself "visible" by means of perceptions. That is also what is meant by "praxis theory" and a simultaneous "theory praxis" of the aesthetic: a tear in the tightly drawn fabric of a banderole in front of a construction site, a wire sculpture in space, subtle traces of erosion as a shadow of time, a stubborn note which ruins a series, an obscenity which places the *ob-scene*, the outside at the center. They unsettle and discomfit because they reject simple classification and remain chronically ambiguous and exactly in this way demonstrate the inability of theory to be brought to a close. Without a foundation outside of perception, they cannot be subject to either plausible explanation or to justification. We could put it this way: aesthetics and its exercises labor in the limitless, without finale or conclusion—in a permanence of becoming which remains inseparable from the ambiguities of perceptions.

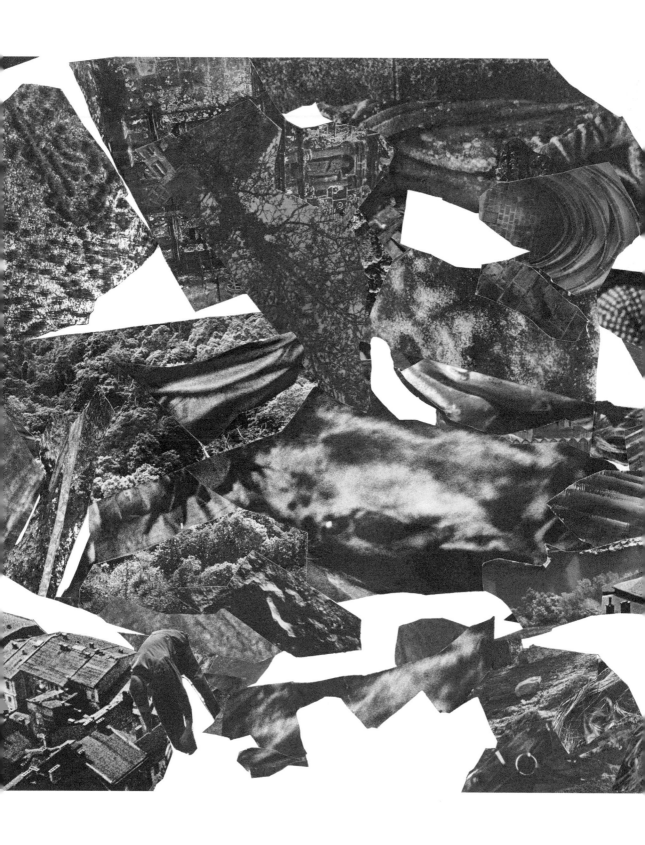

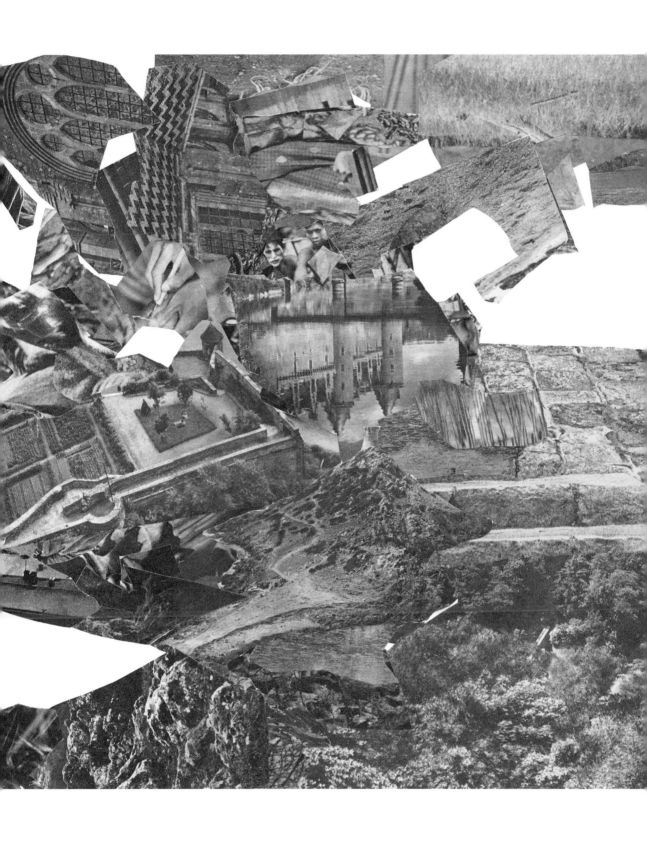

Aesthetic Doing

The linguistic correlate of such a praxis is the verb. Verbs refer to both active and passive actions. They are characterized by both intentionality and non-intentionality. They possess transitive and intransitive qualities, point simultaneously to space, time, agents, and contexts. "The sight of a nut makes me round," as Gaston Bachelard put it: nothing can detain the inconsistency and indeterminacy, the plasticity and precision of the direction change displayed there. Actions, like verbs, only exist in connection with performativa, which define their practical modalities. These can in turn be expressed in language, however insufficiently, through propositions which in the main signify local or temporal vectors. Linked largely by situation or occasion, verbs do not "represent" clearly identifiable acts but rather are located in a network of virtualities which only secondarily disclose what an action will have been: "to make round."

If scientific research protects itself against the counter-finalities and uncontrollable collateral effects of the verb, aesthetic research exploits them so as to successively intensify them and turn them against the certainties of allegedly objective knowledge. By reproducing the potencies of the proposition, they simultaneously multiply directions and possibilities. The classical sciences have in fact over centuries developed meta-disciplines like the philosophy or history of science and sociology in order to restrict and standardize their public action as well as to keep a skeptical eye on it and to review and control the achieved results. It would not just be fatal to imitate them; art requires no such meta-regime. For research in the aesthetic acts beyond the ontologies of the eminent verb "to be" on a delicate field of alternative decisions which allow thinking in heuristics, taking side roads along the way, following uncertain traces or vague intuitions, stumbling finally on the particularity of phenomena which at the beginning were neither perceivable nor able to be reproduced. Research as "aesthetic finding" can thus be derived from experiences which continually re-approach their horizons, and in doing so make remote discoveries which destabilize insti-

tutionalized scientific knowledge, as they at most insinuate while proving nothing.

The term *ex-per-iens* shows this precisely: with the prefix *ex-*, something comes "out" which, in the sense of medial excess, has gone "through" (*per*) something else. The artistic *experimentum* distinguishes itself radically from the scientific experiment in being performed in a continually new and different way, without premonitions or conclusions. Results are rather discontinuations, easings of a continual movement, where awareness is a sediment, which does indeed show itself but is not aware of what it "is," in the sense of its ability to be articulated. It may only expose itself with all the risk of its provisionality.

11. The practice of artistic research draws its energy from conflict.

As examples of such research practices, we could take dichotomies or incompatibilities or tensions that become manifest between things, actions, textures, materials, or images and sound and their respective composition *(com-positio)* in the sensual sphere. Beyond their measurement through quantifying methods, or their conceptual definition, they break forth from the respective contradictions and dissonances, are, as leaps, already thoughts, without needing to articulate themselves as such or requiring a *de-finition*, an exhaustive explanation. This is why we speak so often of "showing": it signifies that form of displaying or presenting which does not require certification through language.

If in this sense artists carry out experimental work *ad absurdum*, building monstrous but pointless machines (Jean Tinguely) and "invisible" memorials of horror beneath cobblestones as sites of a simultaneously present and absent memory (Jochen Gerz), if they, with a view to the factual possibilities of bioengineering, allow a sculpture to get out of hand, to transform its materiality into proliferating, formless flesh (John Isaacs), or if they discover the terror of facial recognition programs (Ed Atkins), if they also subject artistic works or

their media-artistic boldness to the lecture-performance of a critical reflection (Martha Rosler), questioning in the process the aesthetic capital of the museum (Hito Steyerl), then they are using paradoxical or opposite configurations that thanks to their inherent contradiction illuminate something which cannot otherwise be asserted.

Both aesthetic research and specific aesthetic knowledge have their own extraordinariness, self-will, and legitimacy. They must close themselves off from both rationality and discursive logic, as these cannot help but exclude contradictions and banish them from the space of their epistemological work. The opportunities and irreducibility of research in the arts are based on this: they culminate neither in the discovery of quantifiable entities nor of general laws, nor do they pretend to solve riddles or reveal hidden causes; they instead live from uncovering dried-up sources and other points of view which nest in the interstices between unruly phenomena. They prove to this extent to have an epistemological affinity when they highlight the incompletion and interminability of conceptual dispositives and theories in the form of singularities. Their epistemological form is not just the disclosure of heterogeneities but also that of the limits of knowledge and its conventional schemata. Accordingly, research of this kind searches for exactly those aesthetic moments which demonstrate the insufficiency or inconsistency of every form of totalization.

It is no coincidence that Roland Barthes, who thought in all aesthetic fields (literature, theater, photography, design, film, art, advertisement), spoke of the aesthetic as the "impossible science of the singular essence." Our claim follows him: it is not the sciences which push against the margins of sense through their research; rather, it is aesthetic thought that allows them to become productive in its specific praxis of research. Whoever aims at progress in the sciences but regress in aesthetic aims more at regress than progress.

12. **Aesthetic research "is" the thought of how thinking genuinely occurs in the aesthetic "as research."**

"Research in the aesthetic," "aesthetic thinking," and the "practices of *theoria*"—these are synonyms. They reveal themselves not in the formulation of universal ideas or large-scale conceptual architectures which bundle together entire epochs and which occupy generations of researchers (like the theory of relativity, risk society, or deconstruction). Instead, they take place amid installations and action spaces as practical conversions, provoked by frictions, dissonances, or chiastic entanglements and their unavoidable oppositions, and thus also through that which proves to be disjointed, which does not tally, which the gaze gets stuck on, and where the sense of an event cannot be localized.

This does not occur independently of what the respective artists or designers think to realign their thoughts retrospectively into research desiderata, just as little as it suffices to observe them during thinking or acting. It rather depends on the concreteness of the practices themselves upon inspection: as that which occurs in performance, which their performative formatting effects in the moment of suspension, immobilization, or dissociation. The particularity of such practices always suggests itself in conversations or work presentations, especially in those places where the mode of explanation is incommensurate with what is shown or occurs, where speech comes to a halt or searches for work for something that Roland Barthes rightfully considered the sovereignty of poetry: its ability "to almost say something." Describing this ability in most cases requires metaphors, albeit ones which do not come equipped with their sense: they prove at best to be pores on the "unconscious surfaces" of aesthetic thought. Surrealism attempted to turn them into a program, but their energy goes far beyond this: ultimately, they are modes of sensual refusal, of a "strike" (Benjamin), as they fulfill no purpose but rather *medially* communicate *themselves* as means. Research in the aesthetic sphere thus proceeds not via the positivity of analyses, inferences, or results, but instead via undecidabilities, the non-representable or inaccessible, which wreak "havoc" on the fabric of phenomena and their relations.

At the same time, every praxis can in principle be converted into an aesthetic praxis, just as every institution and every social or economic setting can become a subject for aes-

thetic research. All that matters is *how* it occurs, *to what* it aspires, *what* it reveals, and *how and in what way* it makes itself a subject in the process. Research in the aesthetic also does not require an exclusive location; any site, any material, and any social field is suitable for questioning. What is alone decisive is the radicality of the deployment of artistic research, the unconditionality with which it touches and exceeds taboos and limits, as well as the consequence and intransigence with which it emphasizes its concern, its mediality, its practical rigor, but also its inadequacy.

All aesthetic or artistic research operates "zetetically" (in the sense of Pyrrhonean skepticism), i.e. as continual self-observation. It puts on the second gaze, exposes itself to the abyss of its endless subjectivisms, its bodily action, and the one-dimensionality of its expositions and their accompanying discourses or applied dispositives. Aesthetic research in this sense undertakes the annulment of existing frameworks while creating new frames only in order to break them again. It negotiates both inclusions and exclusions in order to reveal *how* these illuminate or banish to the darkness of the "horschamp." Aesthetic research is, in a word, perennial self-doubt, meaning that aesthetic examinations always affect the aesthetic and its practices themselves, just as artistic reflections affect art and its temporally conditional definitions and self-descriptions.

Art thus continually begins anew with every work. It has, so to speak, no set beginning but instead with every new beginning defers being situated, its position and starting point, in this way newly constellating its field. It is in play at every moment: both in *what* it is and *how* it is.

13. **The practices of aesthetic thought cannot be made into algorithms or programs. The qualities of aesthetic practice are re-contouring themselves with the dispositive of digitalization. Acting aesthetically in digital technologies will be the challenge of the future.**

Algorithms and programs follow the laws of repetition and identity. They are based in mathematics, which presupposes the principle of non-contradiction. In the successive execution of their program steps, they *recur* to their respective predecessors but do not *reflect* on their own limits, conditions, and materialities. By being able to integrate the disorderly only in the form of coincidences or statistical variations, they prove to be incapable of exceeding their own mathematical foundations. Art meanwhile is a form of *exceedance*, of transgression and exaggeration into the non-decidable, the occupation of heterotopies as sites of impossibilities. In contrast, the virtual is composed only of possible worlds—possible in the framework of their consistent modelling, which satisfies the requirements of mathematics as an existential index. Incalculable points of singularity can also be calculated approximately, whereas "aesthetic incalculabilities" disrupt the principle of number itself and thus operate outside of the Turing machine.

The meticulousness, relentlessness, and implacability of artistic works are of this kind: they do not exhaust themselves in the operative but allow, as Rilke expressed it, that "the staggering bill adds up to zero." Its excess implies that artistic thinking, in contrast to the algorithm, cannot be brought to a conclusion. It does not get caught in a circle. If circularity in mathematics leads either to paradox or to the necessity of a hierarchy of grades, then the excess or exaggeration of art is an "opening." And nothing more can be said of this opening than that it "cannot occur through a justification of exaggeration" (Düttmann)—for self-surpassing thought tolerates neither deduction nor a meta-vocabulary.

This means, however, that aesthetic praxis will be simultaneously challenged and fostered by the digital and its machines. For in both the disappearance of the analog and in the technological-mathematical transformation of perceptions, actions, or skills, there is conversely an opportunity for the restoration of the aesthetic. But it cannot be identified as a remnant category with the allegedly lost, the analog, because the evocation of the other, the heteronomous, is itself still socialized by the digital and its technologies. Instead, the experiences which guide aesthetic practices today are digitally

cultivated, which simultaneously means that digitality and aesthetics are inextricably interwoven with each other, and even interfere with each other.

The digital as an order of the discrete, which makes possible decidability and calculability, is again drawing the world into the intangible and thus also into an inconceivability. Its hegemony is based on the bundling of complexities, which demands clarity even in those places where ambiguities come into effect: in the indifferent, in touching in darkness, in affects and feelings, in care and social relationships. In this way, perception becomes *recognition*, and care is replaced by social media. But constitutive blurs cannot be clarified through digital scalings, for in the digital, "0" also means "0" when there is something more than nothing—just as "1" also means "1" when less than something exists. In contrast, aesthetic practices measure the inexact, act in the sphere of the approximate, which cannot be noted as a decimal number between "0" and "1," as the blur cannot be numbered, not with "0.5," not with "0.333...," not even with another, possibly transcendental number. *Fuzzy logic* is just as little able to make the incalculable calculable. The aesthetic is rather based on the kind of estimation which cannot be carried over into any kind of measurement. Art is thus neither what can be captured with binary operators nor what lies "between" the binaries as remnant categories: it is rather a praxis which requires a change in terrain.

If in the future the measurable side of the world should become totally ascertainable through digital actions, it does not yet follow that the non-measurable will fall into irrelevance or that the unmeasurable side of reality will be sacrificed as a vestigial stage of digitalization. This is impossible for the simple fact that the technological marketing regime even exploits the aesthetic and our aesthetic connections to the world in order to mediate between us and them. Acting aesthetically in the digital technologies and interfering with them will be just as much of a challenge as the one facing art to lay bare the prejudices and narrowness they contain. Research in the aesthetic sphere is promising in exactly those places where it multiplies such challenges and continually provokes the digital in new ways. Its activities accordingly prove to be most meaningful

where they offer resistance to the business and busyness of measurement in order to lend another precedence and adequacy to non-definability and indifference (or in the sense of Emmanuel Levinas: "in-indifference").

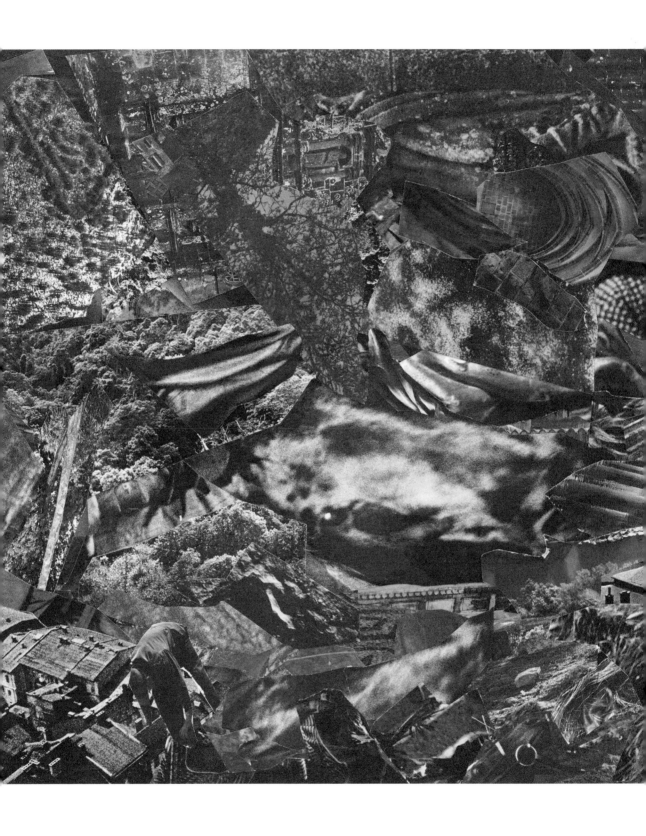

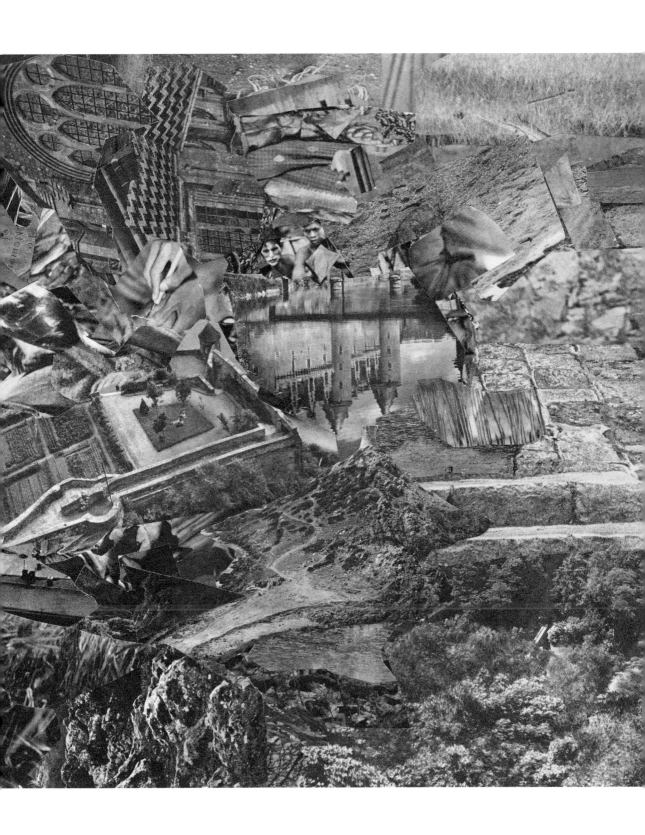

For an Intellectuality of the Aesthetic

Art has undeniably taken on the character of a "system." Labels like "artistic research," "practice-based research," and the like reproduce this system in the mode of its immanent professionalization. Meanwhile, it seems unpopular to speak of a historical break according to which art has given up its role as "governor" (Adorno) of another, "better" world, to instead function as a "research machine" which has stripped away everything utopian, now defaming it only as "romantic." But the meaning and self-understanding of artistic activity still depends on its role as a critic of social developments—like the union of technology and neoliberal capitalism. Such criticism also does not stop with "critical" art, the success of which substantially depends on access to the close-knit, elitist, and deeply undemocratic networks which organize the system. Whereas flexible artistic working methods have been established since the New York era, the art system with its motor, the art market, despite all of its critical self-presentations, shows itself to be more restrictive and authoritarian than ever before. The networks to which both galleries and curators contribute, to which little more than 0.1 percent of acting artists worldwide belong, are with few exceptions impermeable. All others remain in a state of precariousness.

The consequences are notable: on the one hand, the "art system" with its institutions like exhibitions, museums, festivals, art prizes, and training facilities seems to be less focused on the fostering of the arts than on the procedures of their selection. On the other hand, the criteria of this selection are not measured against inherent aesthetic criteria. For the question is whether that which makes up art has not become so non-specific as to have become foreign to the aesthetic. There hardly exists anymore a binding concept of what is considered "artistic" other than, of course, the fact that such a concept no longer exists. "Institutions theory" has apparently totally triumphed over art: art is that which is publicly considered art. This tautology, hardly able to be overcome anymore, implies

not only that the art system regulates access to its holy grail but that it has simultaneously gained total definitional power over what distinguishes art from non-art or "anything else," as Ad Reinhardt polemically put it.

Nevertheless, against the background of this development, the question arises as to the location from which legitimate critical intervention is still at all possible. We claim that there is no better way to cast a critical glance at the art of the market and its systematic managers than through those aesthetic practices which art itself makes use of. What or who is better equipped for this critique than the very aesthetic thought on which art is based, and that, as discussed above, necessarily focuses on itself, turns against and reverses itself, and pushes itself beyond its own limits? It is the particular intellectuality of the aesthetic which manifests itself in the ability to exceed itself, to go beyond itself, to surpass itself, and precisely in this way to revolutionize art. If it makes sense to speak of the "freedom of art," then it is only because this intellectuality of the aesthetic can be realized in it.

14. Aesthetic thought means a continual praxis of self-critique. As such, it is founded on "freedom."

Recourse to the aesthetic method of "transgression" and not to art as a "system" or a series of objects and processes can also be read as an insistence on the intellectual capacities of the aesthetic. The aesthetic as a site of critique operates as a reflexive praxis which reveals the "conditions of acceptability" (Michel Foucault) of the given and thus also of the "art system." Aesthetic research, differently from artistic practice, is not a motor for the overproduction of artistic positions within the system, is not a machine of knowledge. It instead materializes in modes of zetetic self-research which simultaneously contain the necessary aspect of criticism of the state of art.

This also means that the focus on the intellectuality of the aesthetic is not identical with the question of art or the artwork. The question is not the kinds of objects or performances that define art today, which spaces art occupies, or who de-

sires to participate in it. The question is rather what the figures or procedures might look like through which aesthetic thought develops its specific intellectual potential beyond the question of the status of art. At the same time, the retreat to critical practices allows their redefinition. Even if the understanding of aesthetic procedures have always fed on art and art criticism, this cannot be sufficient, as art criticism itself seems to be ensnared in the networks of the system. We approach the core of aesthetic thought only once we set aside the question of art and its authorial gesture as well as the respective actors, specifically the artists and the correspondences between them and their audience or professional exhibiters or interpreters. We must break through the forms of their self-mystification in order to reveal what aesthetic research can be in the sense of aesthetic thinking: an unbroken chain of self-critique.

In his *Critique of Judgement*, Kant famously distinguished the aesthetic from the logical and assigned the logical to rational knowledge but the aesthetic to the "reflective power of judgment" and to judgment generally. A form of thought then becomes visible in the aesthetic which thinks differently from discursive-theoretical thought, where the judgment becomes a proposition and the proposition becomes a propositional definition. That aesthetic judgment nonetheless represents a paradox has long been emphasized: above all, Kant continues, because it simultaneously constitutes both subject and community and, in the form of its judgment, questions not just the judged but also the praxis of judgment itself. But such an interrogation in the shape of concrete "sensual formulations" refers before anything else to the reflexive and intellectual capability of aesthetic thought, which is why it seems worthwhile to recall the oft-cited Kantian formulation of the "free play of the cognitive powers" (*freier Spiel der Erkenntniskräfte*). It confirms a dynamic in the process of the aesthetic which insists on "freedom."

Freedom is always unconditional. It refuses to be constricted or bound by definitions and recognizes no origin or norm emerging from itself. It is as anarchic as it is anomic. The intellectuality of the aesthetic which insists on freedom culminates not simply in the reflex of wanting to free itself

from something, but rather signifies a form of action which constantly goes beyond given facts—a freedom *to* which consists in exaggeration and self-surpassing. Aesthetic thought is for this reason intellectual, as it simultaneously includes the potential to make distinctions in the practical, in material and its forms, and to make these experienceable in a singular way. In opposition to causal verification, to deduction or generalization, it behaves in a tangible, touching way towards its objects. It accords and considers, not to ambush these objects but to acknowledge and accept them, and thus to show their incomparability and vulnerability, and to show what remains unsatisfied by art.

We can consequently also not determine what aesthetic thinking *is* or what "research in the aesthetic" means and what symptoms it has. It remains precarious. We can only decide on a case-to-case basis or name specific practices which, bound to their specific situation, move relative to time in order to penetrate and "pierce" the layers of time in continually new ways. Research in the aesthetic thus lays claim to its own legitimacy *as* research, independent of any theoretical, discursive, or scientific acceptance.

What remains is doubt. This constitutes a principle of production. It produces: aesthetic reflexivity.

15. **The precariousness of aesthetic research is also its potential.**

Sabine Hertig
Bildstücke, 2019

Declination of the Collage 0221 (German edition of the manifesto)
Untitled, 2017
42 x 90,5 cm
Analogue Collage on wood

Declination of the Collage 0222 (English edition of the manifesto)
Untitled, 2017
40 x 75 cm
Analogue Collage on wood

The piece *Bildstücke* (2019) was created in dialogue with the manifesto.
It exists only in the present bookform, but was developed out of
two previous collages from 2017. The process of declination and
the implied dramaturgy is connected with the "book" as a medium
and its artistic investigation.

Sabine Hertig is an artist and studied at the Basel FHNW Academy of Art and Design.
Since 2013 she is represented by the STAMPA gallery in Basel. In 2013 she receives
the Culture Prize Riehen, in 2017 the Cristina Spoerri Prize. In 2018 her first com-
prehensive monograph "Sabine Hertig scrap" (Ed. Ines Goldbach) was published by
Christoph Merian Verlag. She exhibits regularly at home and abroad.
www.sabinehertig.ch